D1261810

FLOWER ALBUM

DIETMAR BUSSE

First published in the United States of America in 2003 by
Glitterati Incorporated
225 Central Park West
New York, New York 10024
www.GlitteratiIncorporated.com

Created in conjunction with

THE NEW YORK BOTANICAL GARDEN

Distributed in North America by powerHouse Books,
a division of powerHouse Cultural Entertainment, Inc.
180 Varick Street, Suite 1302, New York, New York 10014-4606
telephone 212 604 9074, fax 212 366 5247
email: FlowerAlbum@powerHouseBooks.com; web site: www.powerHouseBooks.com

First edition, 2003

Library of Congress Control Number: 2003100423

Hardcover ISBN 1-57687-175-4

Photographs digitized by Pace/Editions.

Printed and bound in China by Hong Kong Scanner Arts, Inc.

10 9 8 7 6 5 4 3 2 1

FLOWER ALBUM

DIETMAR BUSSE

Preface by Anna Sui • Foreword by Sarah Brown
Essay by Tom Breidenbach

Botanical text by The New York Botanical Garden

powerHouse Books
New York, NY

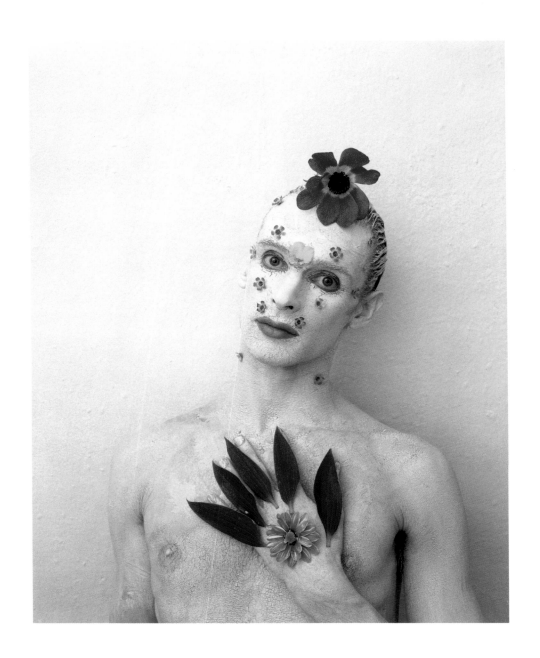

THIS BOOK IS DEDICATED TO MY MOTHER AND FITTY

—Dietmar

CONTENTS

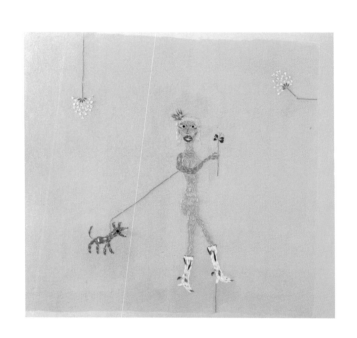

PREFACE

Dietmar Busse, former fashion photographer, creates his own collection of "floral" fashion. He draws from his background and experience in capturing beauty and images with the camera. Mr. Busse steps from behind the lens to a bold position as the model. The artist essentially becomes the artwork by becoming a human canvas. He makes quite innovative use of the parts of a flower and creates the image against the backdrop of his own body.

The eye flows from the elements of the floral presentation to the human form and then back again. The parts of the flower are rearranged to the outline of the fingers, the hand, the arm, the shoulder, and the torso, etc. This becomes a dilemma: The viewer must make a visual choice whether to view the nude or the assembled flora. Refocus, the vibrant color becomes the draw and the contrast of skin, whether bleached white or dark ebony recedes. What remains is the image of a palette that only nature can create. As with all fashion, the designer attempts to draw the audience's attention to particular areas of the human form. Oftentimes, the desired effect is that of a "total look" without the use of focused crosshairs.

A flower erupts into a flurry of color. Colors define patterns. The pattern will become the basis for design. Reassembling the parts of the flower to create a visual pattern and the use of the human body as the background for the visual imagery creates a seldom seen energy, a virtual "floral" fashion show.

Anna Sui
January 2003

FOREWORD

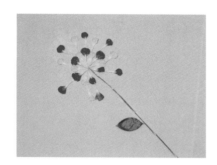

"What I know about beauty is that I'm terribly attracted to it and I can't stop looking at it once I find it." This is what Dietmar Busse told me. Beauty, he continued, "…is in ani-

mals, people, plants, and certain moments." Those moments are what he has captured in this book. It is his *Flower Album*—a collection of recorded moments in which flower petals, leaves, stalks, and stems are reconfigured into new flowers—imagined flowers—that adorn the artist's own body as armor of the sweetest kind.

Busse never set out to create a flower album. The images in this portfolio came to be accidentally, born out of an initial, spontaneous moment—a fit of rage, in fact—when the artist, so displeased with a photograph he was trying to capture ("exceptional" is how it had to be), took a bouquet of flowers,

the subject of the picture, and ripped them to shreds, scattering the pieces about his studio floor. Later, as he quietly picked up the shredded remains and intuitively formed them into a new flower, something surprising happened: From this initial act of violence, aggression, absolute loss of control, and ultimately, catharsis, something delicate, humble, perhaps even more beautiful emerged.

Busse soon found himself scouring flower markets across Manhattan for hibiscus lilies, dentrobium orchids, Shasta daisies, chrysanthemums, and every variety of tulip and rose. Once home, he disassembled and reassembled them, delicately laying his imaginary plants out like scientific specimens—nature's work reconsidered. In Busse's flower kingdom, an anemone blossom sprouts carnation leaves and grows from an aloe stalk (*Flower*, December 4, 2002); wildflowers assembled from lilies, Dutch irises, and gerbera—so frail they might snap if confronted by the gentlest breeze—grow side by side on a two-dimensional plain (*Field*, April 1999).

As the work evolved, it moved from the wall to the artist's own body. As creator became subject, a new intimacy and intensity developed: Busse's flesh, painted white, became the canvas; slowly, the man became the flower. Though he insists that he approached each piece "without any specific goal or picture in mind," the images that emerged proved deeply personal—so personal that the artist is often at a loss to describe them in words. "I started to transform myself, going from one place to another, and a lot came out," he says. "That's what you do as an artist. You take what's on the inside and put it on the outside."

The resulting self-portraits find Busse, self-conscious, naked before the lens of his own camera, playfully displaying a decadent tulip petal pedicure (*Foot*, November 22, 2002); and dressing up alternately as a tribal chief crowned with a headdress of tulips, leaves, and gerbera (*March 2, 2002*); a centaur with a pink lily horn and legs festooned with a thousand hibiscus petals (*November 21, 2002*); and a warrior elaborately armed with lush green dieffenbachia leaves (*December 6, 2002*). Flower petals

are fashioned into feathers—or perhaps fur (*Self Portrait as a Child*, April 1999); an anthurium is cleverly disguised as a Venetian opera mask (*Venice*, December 2002; and *November 31, 2002*); and rose petals cascade like crocodile tears (*November 26, 2002*).

Busse's self-portraits and pictures of imagined flowers explore the almost infinite, frequently competing aspects of beauty. They are studies in contrast: at once fragile and fierce, precise yet imperfect, orchestrated while utterly accidental, organic yet artificial, humble but proud, savage and sweet, sexual and naïve. The artist himself appears vulnerable and exposed, yet safely hidden behind a veil of paint and petals.

What is perhaps most moving, most beautiful about this work is its ability to exist in such a delicate balance—fragile, fleeting, yet rendered inherently permanent by its medium. How heartbreaking—or exciting—it is to imagine those dismembered flower pieces in that split-second after Busse snapped their pictures, and during the ensuing hours, or minutes, while they were still lush with life and bright with color, before their petals curled at the edges and folded up into themselves, and their mangled stalks turned brown and burnt at the ends. Perhaps that's the real meaning of beauty—finding the poetry in something so temporary, so precious, something, that as Busse notes, "can break at any moment."

Sarah Brown
December 2002

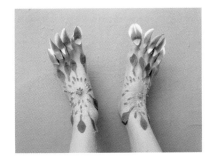

THE PORTFOLIO

JUNE 6, 2002

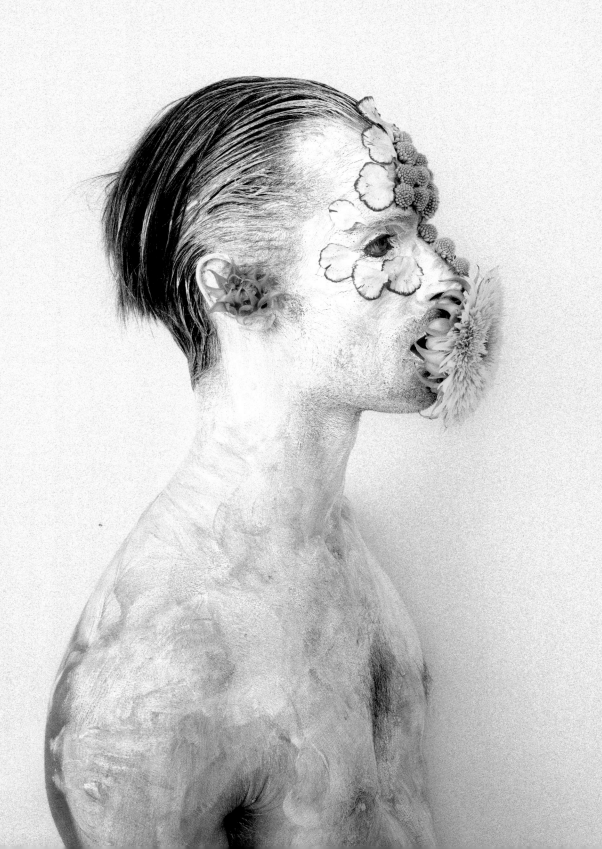

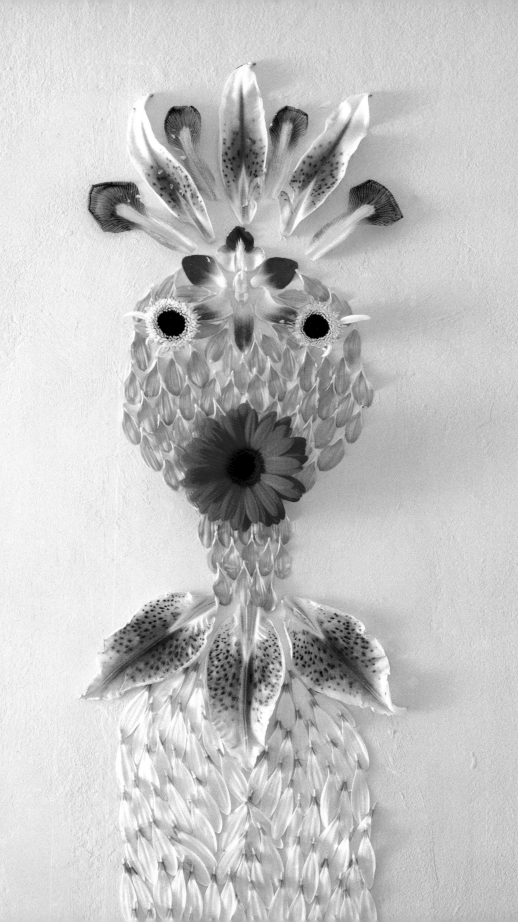

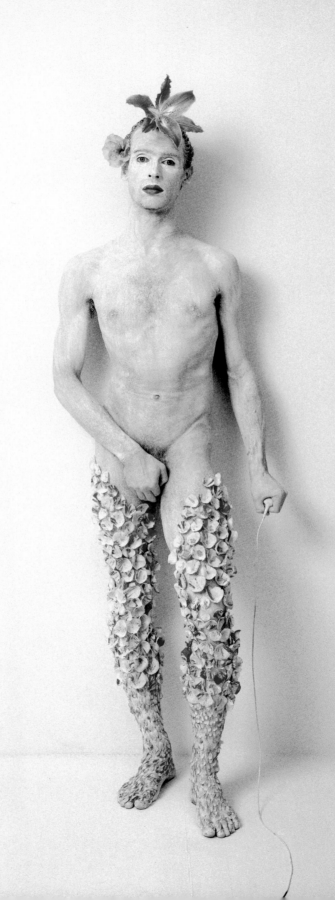

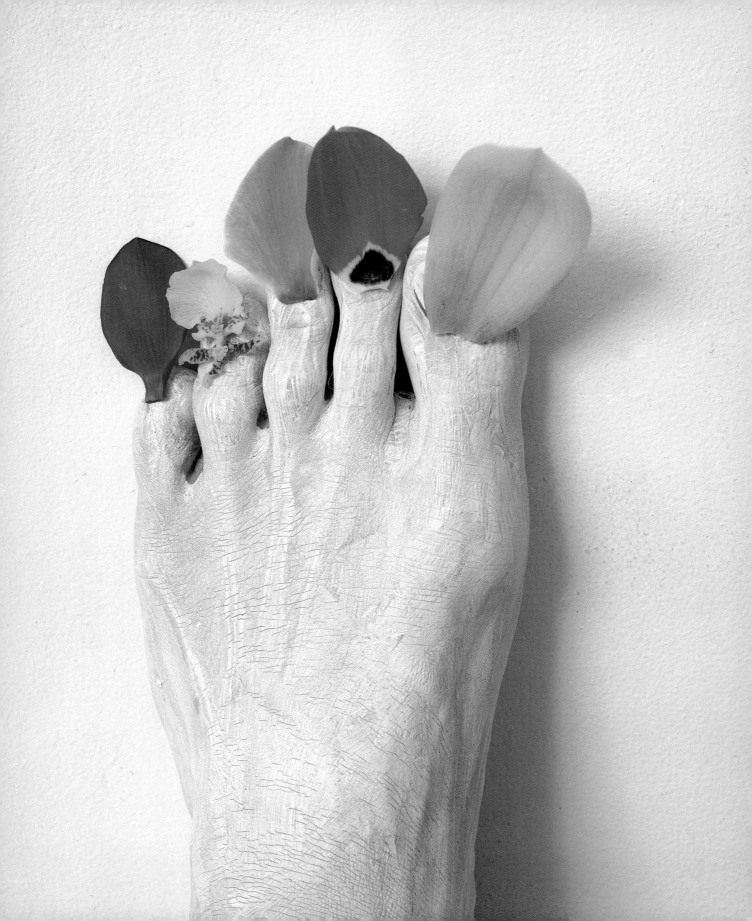

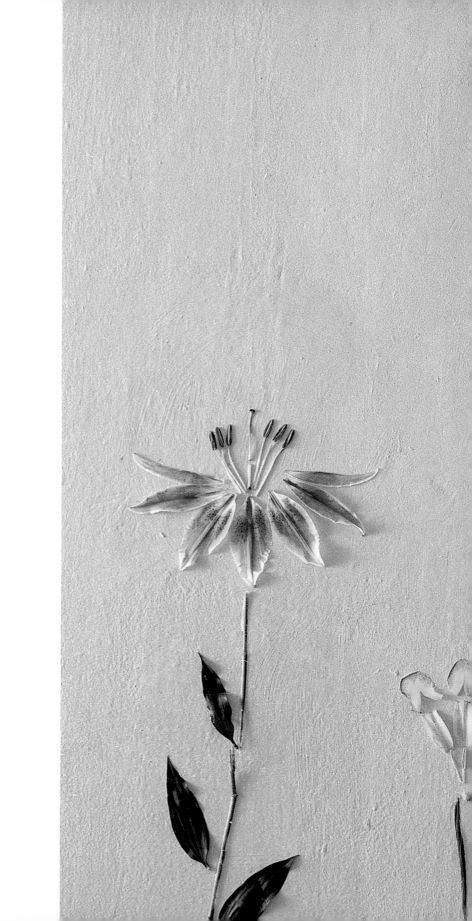

FIELD, APRIL 1999

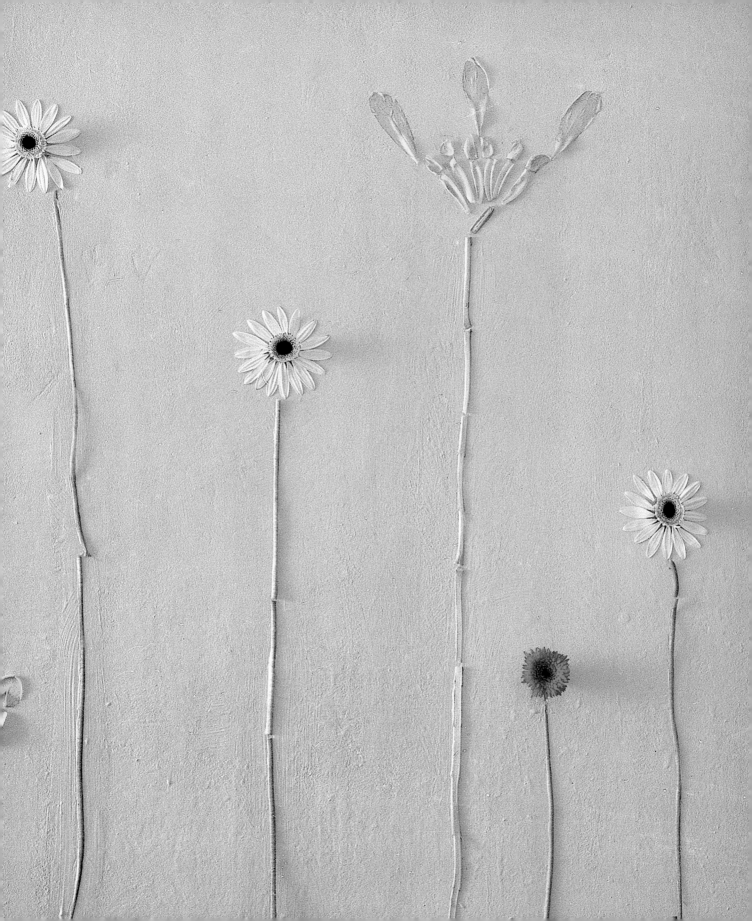

MARCH 5, 2002

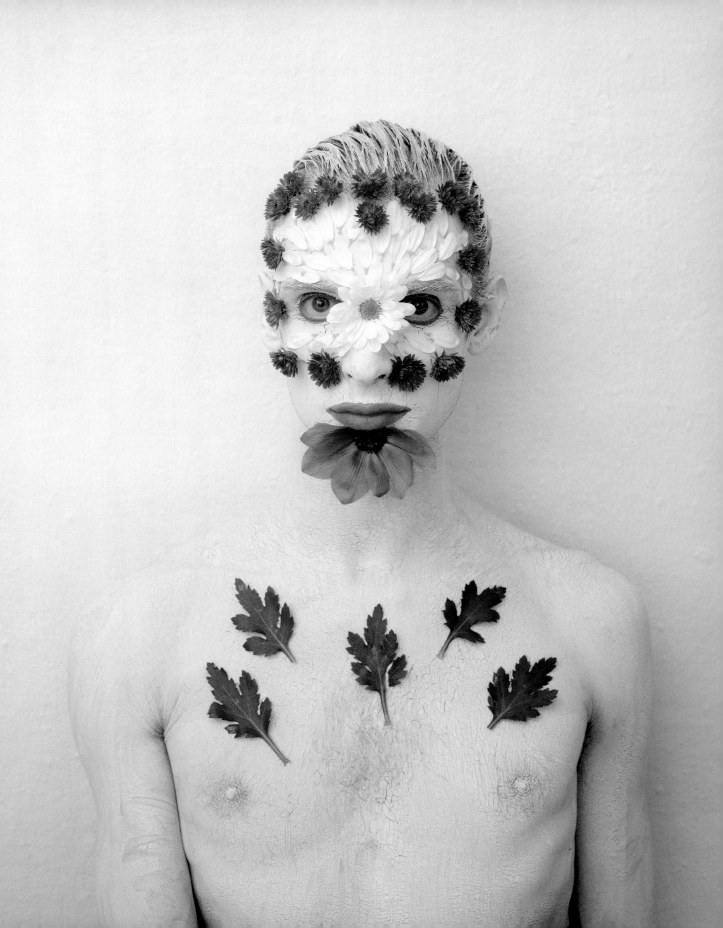

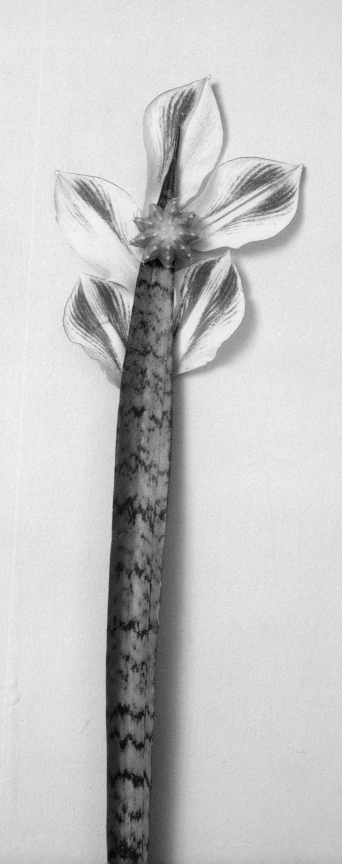

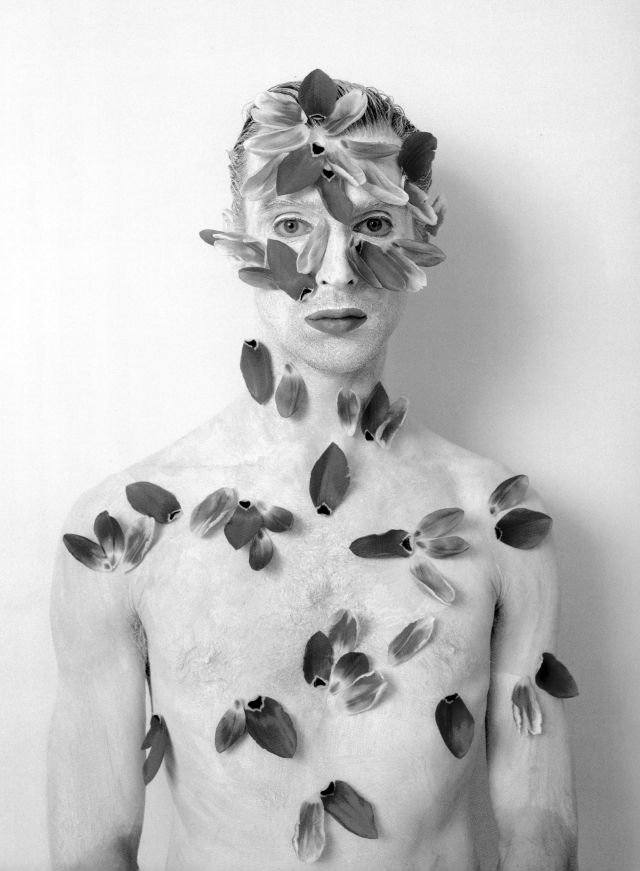

previous pages:

FLOWER, DECEMBER 5, 2002
NOVEMBER 26, 2002

DECEMBER 6, 2002

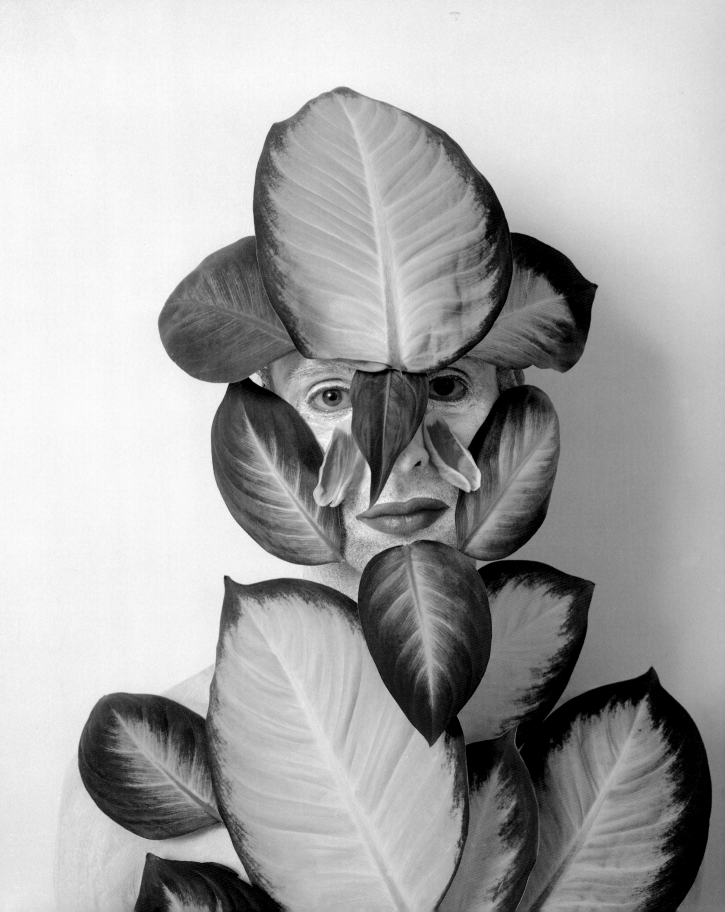

MY MOTHER, MARCH 2002

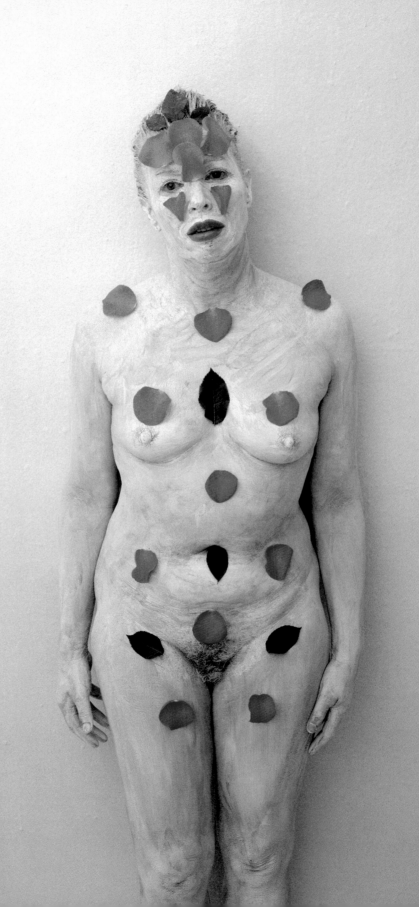

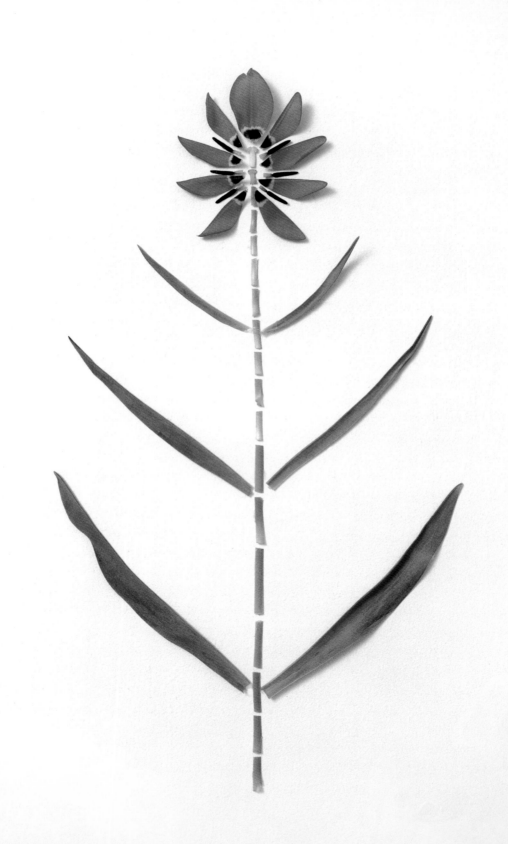

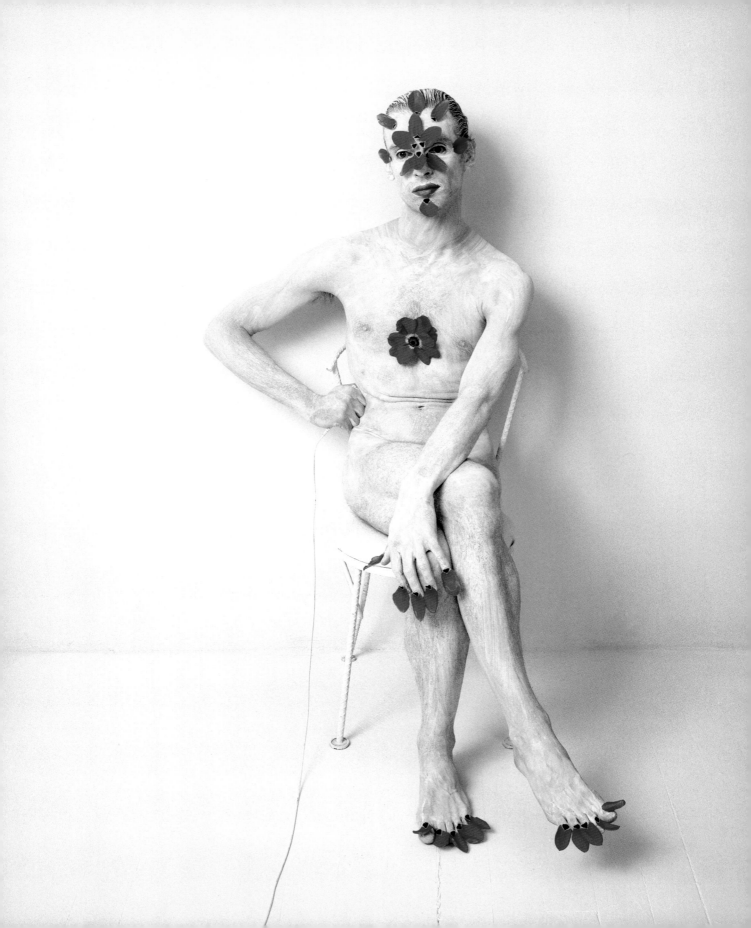

previous pages:
TULIP, DECEMBER 2002
NOVEMBER 22, 2002

JANUARY 18, 2002

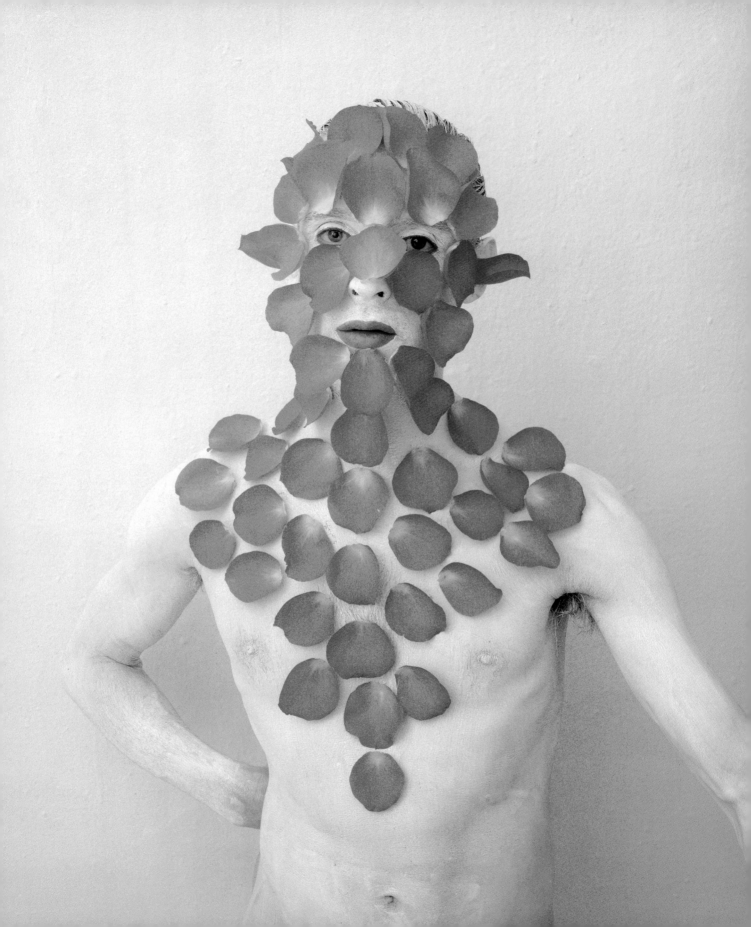

ANGEL, MAY 1999

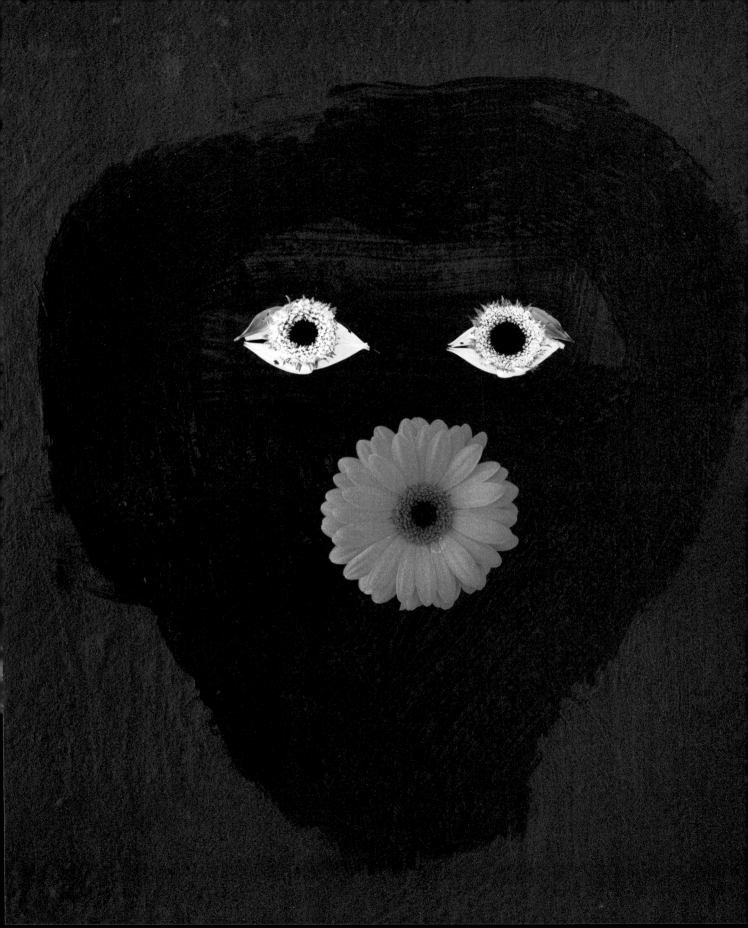

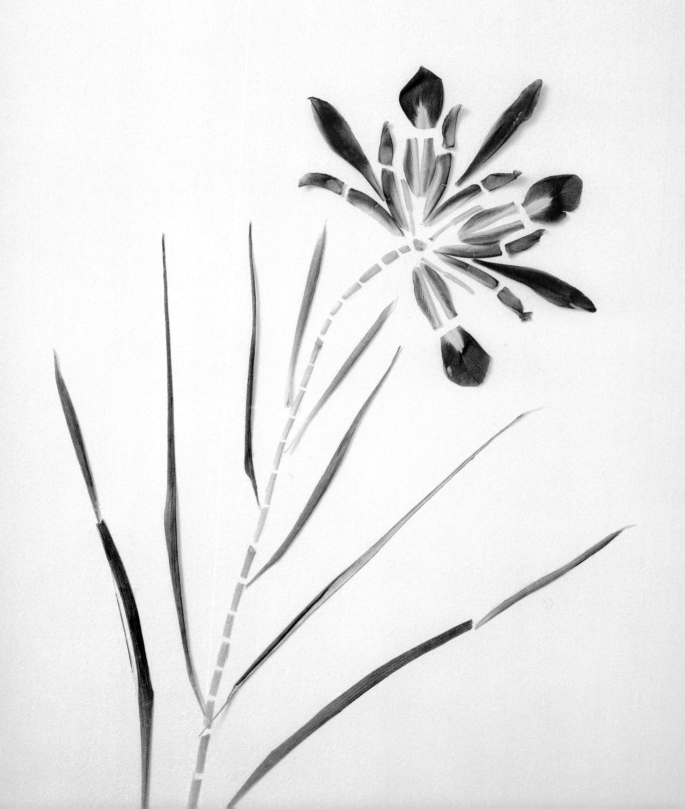

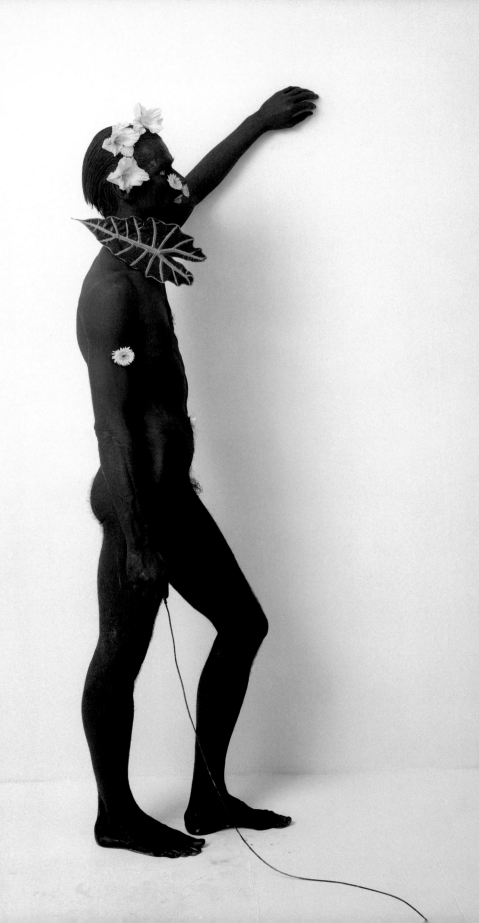

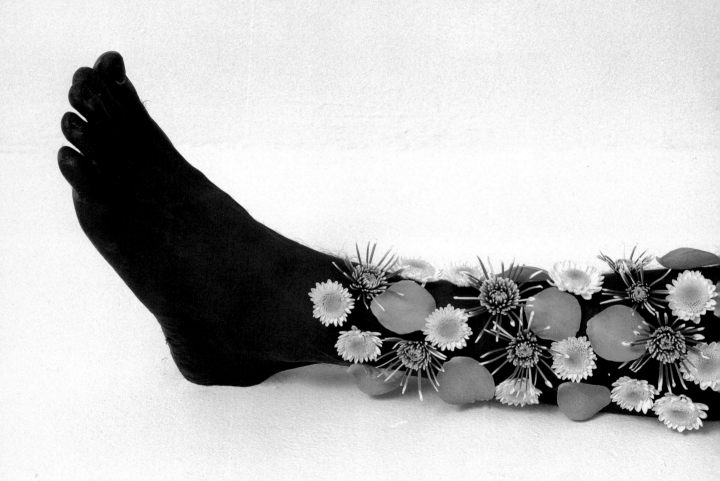

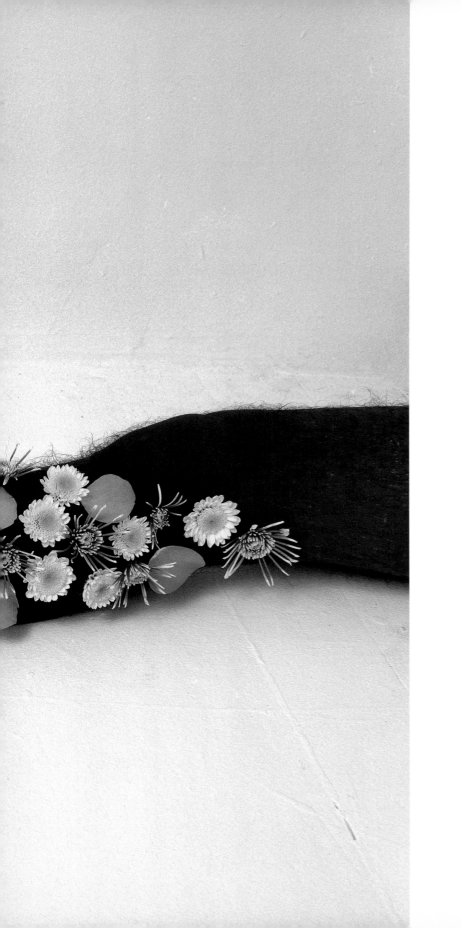

GAUGIN, JUNE 2002

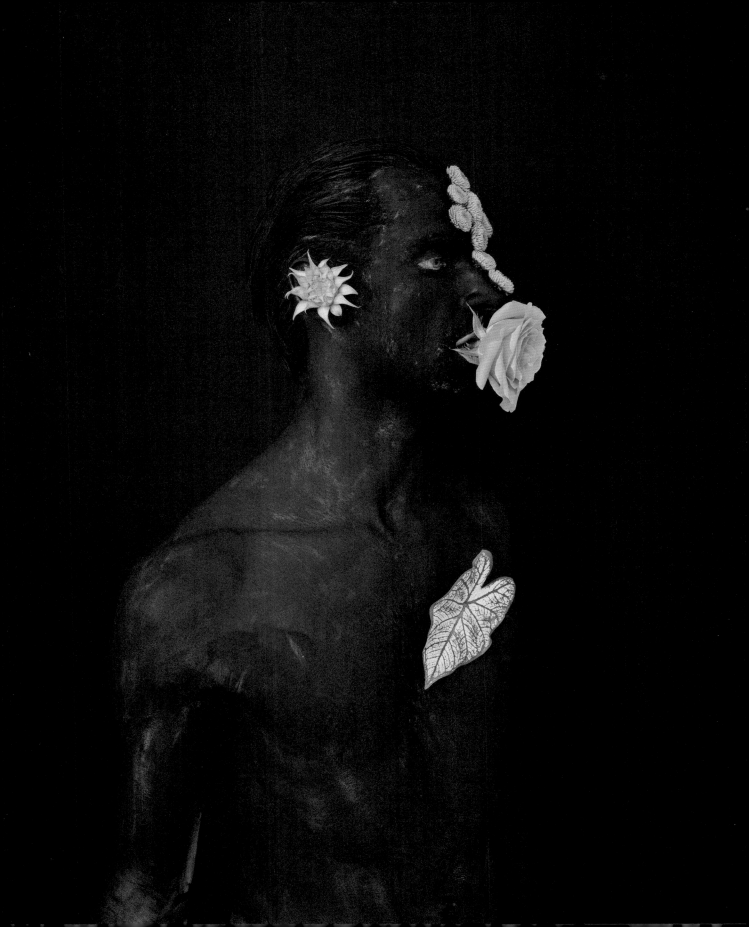

VENICE, DECEMBER 2002

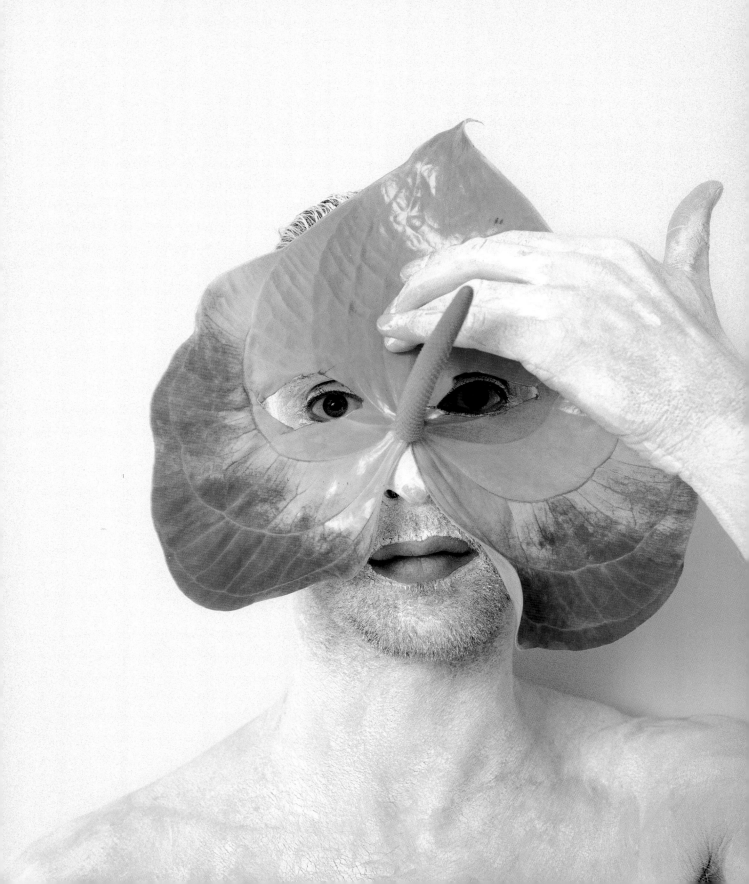

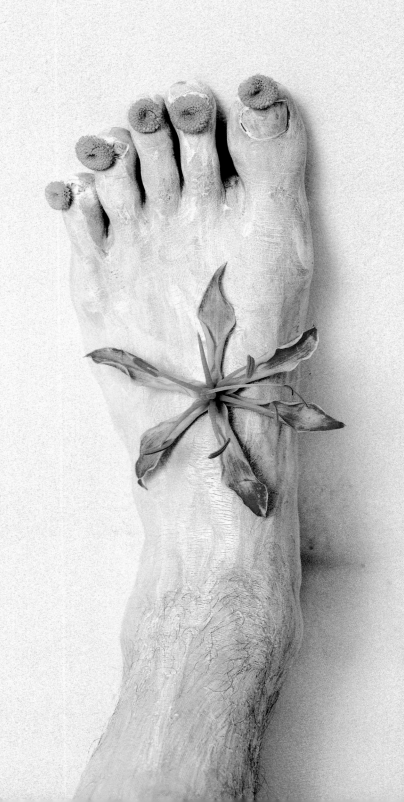

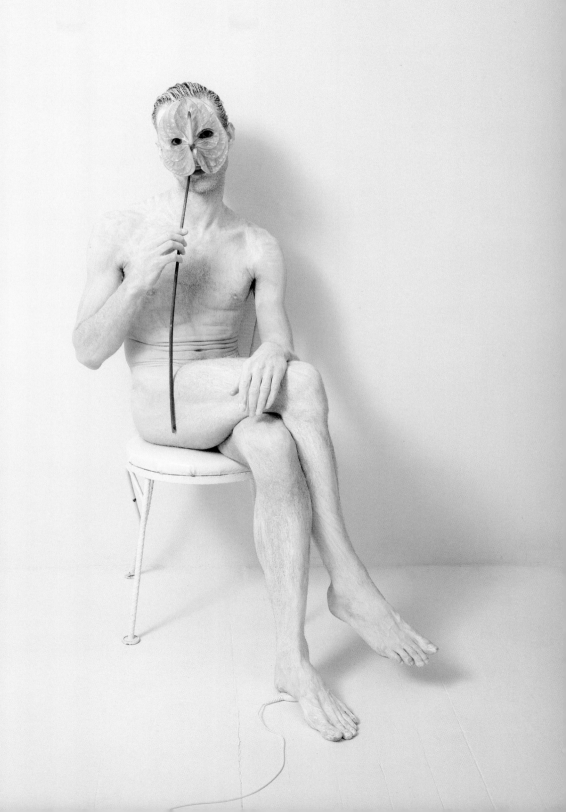

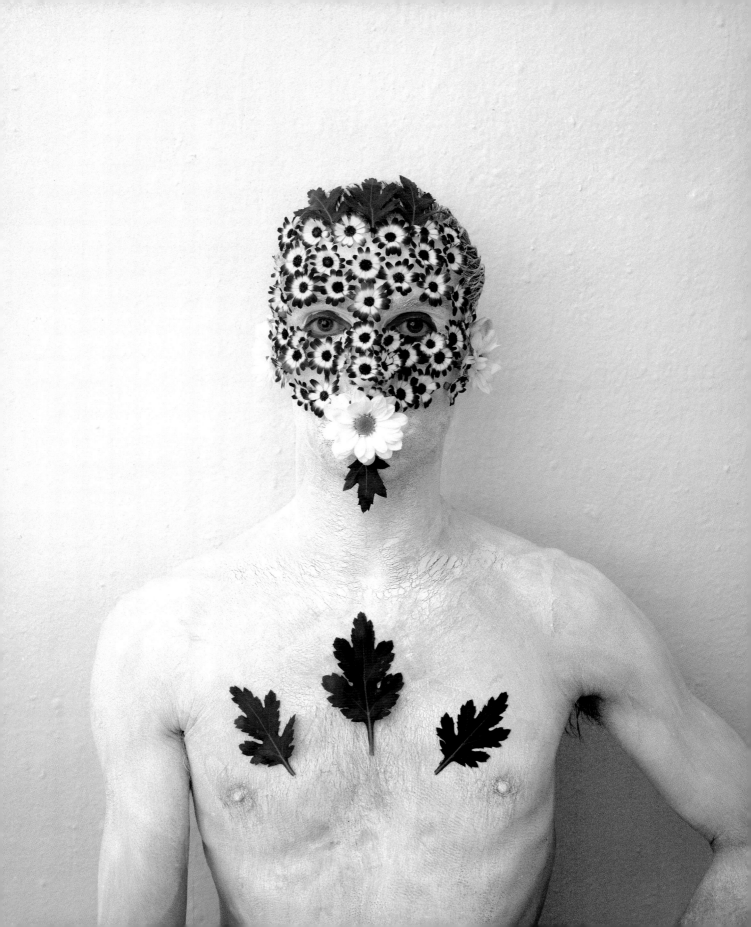

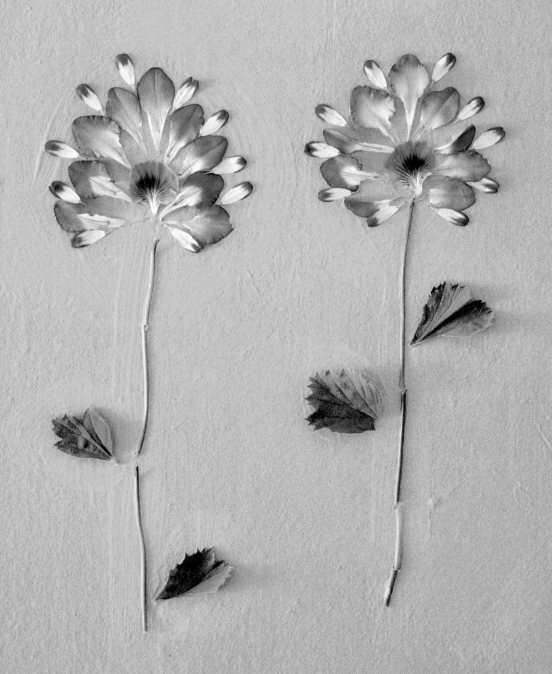

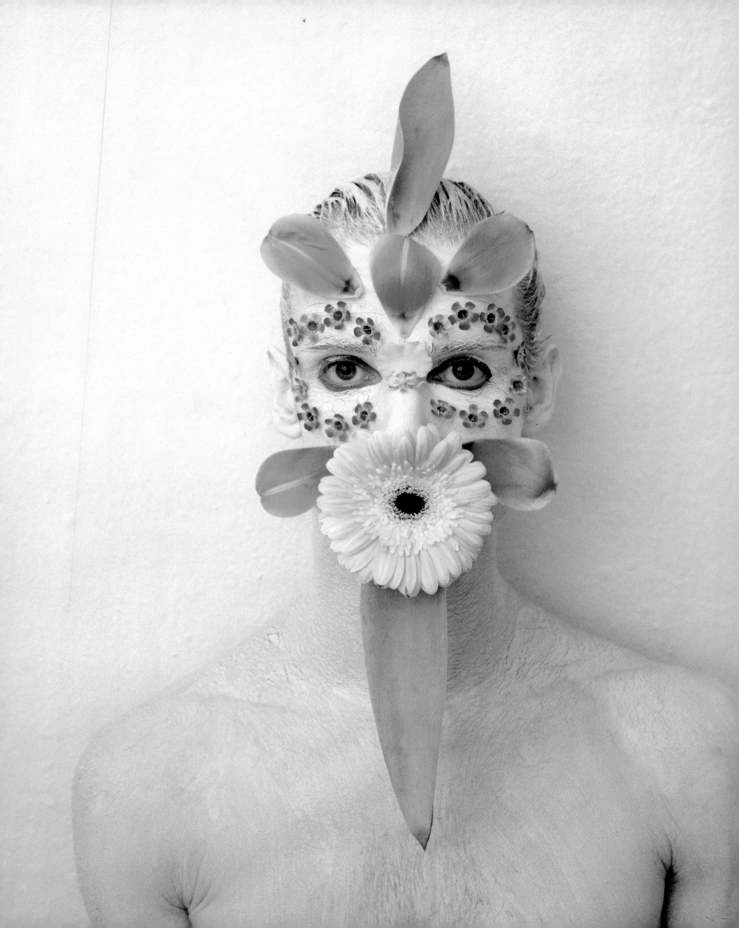

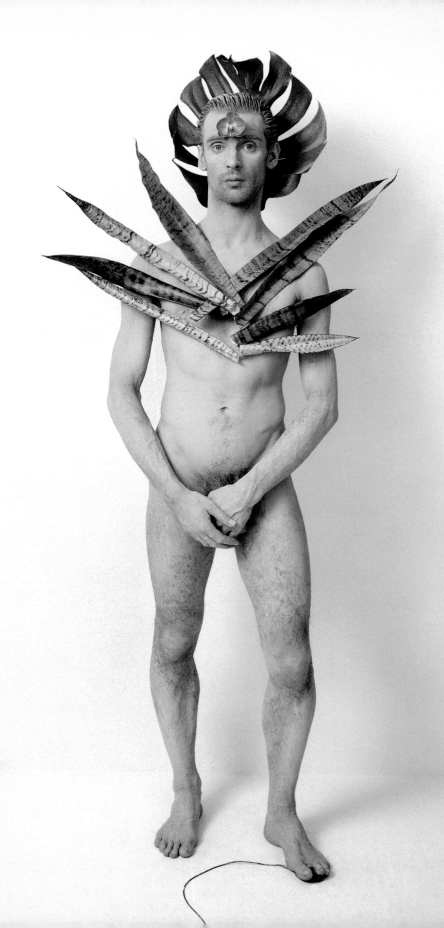

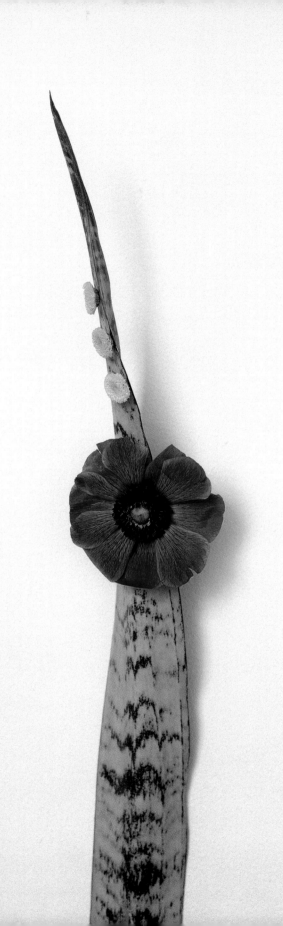

previous pages:
COUPLE, APRIL 1999
MARCH 2, 2002
AMAZON KRISHNA, DECEMBER 2002
FLOWER, DECEMBER 3, 2002

DECEMBER 4, 2002

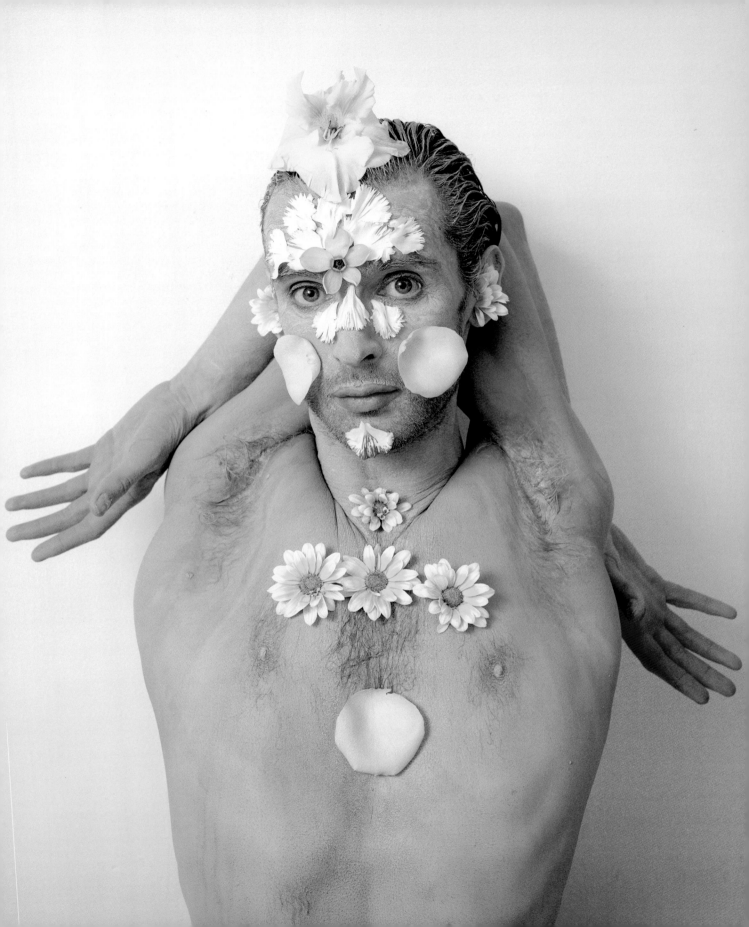

RED, DECEMBER 2002

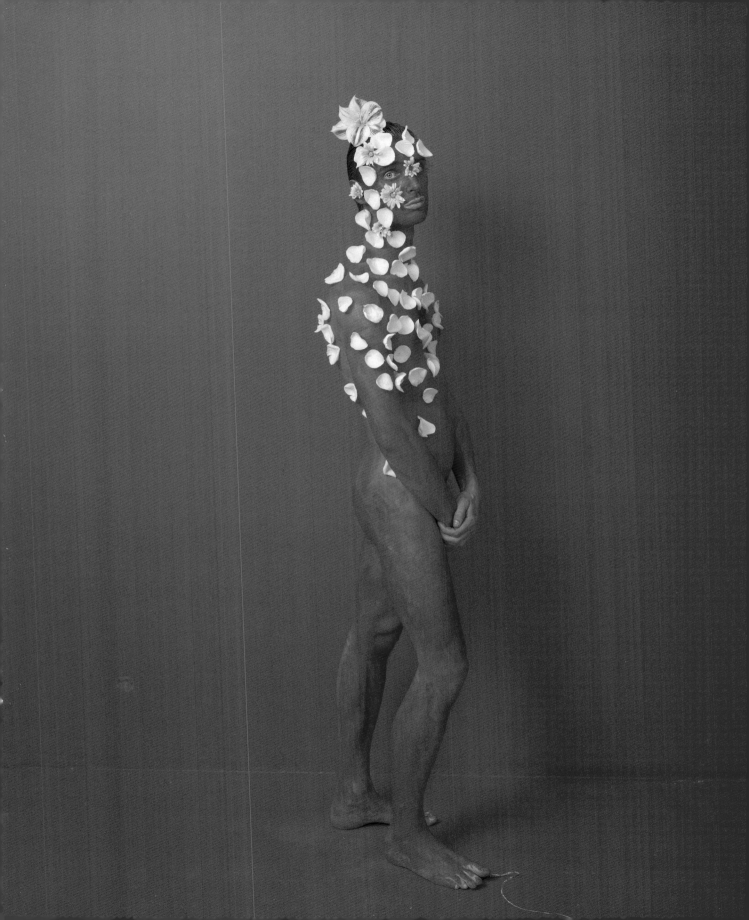

PRETENDING FOR REAL: DIETMAR BUSSE'S FLOWERING

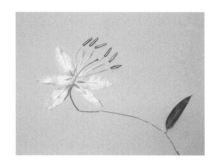

"I see my soul reflected in Nature…"
—Walt Whitman

Dietmar Busse's *Flower Album* was conceived four years ago, when the artist, then primarily a portraitist and fashion photographer, was attempting to take pictures of flowers to give to his mother on

her birthday. He kept finding that something crucial was missing in the pretty but familiar images he was coming up with. Finally, in a burst of frustration, he seized his subjects and mangled them. This momentary rage would nudge Busse beyond his aesthetic impasse; he found himself arranging the stems, petals and leaves of the shredded plants into exciting imaginative configurations. To honor the delicate flowers, he painted monochrome backgrounds on which he placed their parts while the paint was still wet. Then he photographed his art.

Beauty, anxiety, violence—this archetypal narrative is reflected in Busse's art and life. Born in Germany in 1966 and raised a single child on a

working, or what every farm boy calls a *real* farm, Busse describes his childhood as both beautiful and traumatic. Dietmar's only solace was nature—the fields, the woods, the animals and the creeks. He would sit for hours behind his grandparents' barn. "Those were among the most beautiful moments of my childhood. I was mesmerized by the animals. There was real harmony and I felt completely connected." Busse's reflections recall Whitman:

I think I could turn and live with animals, they are so placid and self-contained,

I stand and look at them long and long.

They do not sweat and whine about their condition,

They do not lie awake in the dark and weep for their sins,

They do not make me sick discussing their duty to God,

Not one is dissatisfied, not one is demented with the mania of owning things,

Not one kneels to another, nor to his kind that lived thousands of years ago,

Not one is respectable or unhappy over the whole earth.

Having finished school, Dietmar moved to Berlin, and traveled extensively before ending up in Madrid, where he spent the next four years as a photographer's assistant. In 1991 he came to New York and over the next ten years he became successful in both his commercial and personal work.

This book marks his emergence, after more than a decade of commercial work, as an artist. Here he presents to the world creatures from a childlike imagination, versions of the "pretend friends" one imagines have been in some measure responsible

for his—and every child's—survival. This "being necessary" imbues the characters with a certain reality. Perhaps like poltergeists they are personas of the psychic realm that manifest particularly in instances of acute stress.

On initial take, blithe and whimsical, these images record a sort of private ritual of transformation that involves sacrifice—plants in the fleeting if heightened moments of their dying. The use of verdure by Busse is anything but gratuitous, recalling research that suggests sentience on the part of members of the floral realm, regardless of the fact that their critical role in our own lives normally (and lamentably) goes unrecognized. The plant kingdom is invoked as a sort of witness to, and participant in, Busse's experience, the immolation of flowers being central to the rite, their deaths seeming to vivify the transformation he undergoes. Busse's satyr in *November 21, 2002* is also Pan; the god of nature associated particularly with vegetation whose name implies "everywhere." One recalls that Goethe considered plants to be more highly evolved spiritually than animals, including ourselves, one assumes.

Flower Album's idyllic aspect is further tempered by the browning of decay just setting in at the edges of the leaves in *Flower, December 5, 2001*, as well as by the caked, cracked, chalky texture of the body paint applied over Busse's skin in *June 6, 2002*. Illustrated in the contrast between flower petal and caked skin is the tension between what persists and what fades, the former seeming to lose something, to harden and toughen, while what is beautiful appears called upon to die. Appropriately then, these works conjure spring, usually thought of as a pastoral season, but which is also a time of violent blood rituals both in "primitive" as well as Judeo-Christian cultures. There's allurement on the one hand, a sort of blank innocence that's belied, on the other—however faintly—by a sense of feral menace, that tinge of the eerie essential to fairytales.

The ambivalence is sustained in images of the artist as a harlequin in *Venice, December 2002*, Pierrot in *November 31, 2002*, or the owlish presence in *March 5,*

2002 and *March 6, 2002*. His expression is by turns inviting, kind, impassive and inscrutable, as if he's regarding us as a member of an alien species—or as a child—might. At once exposed and modest, sensual and demure, the figures into which Busse metamorphoses are androgynous, outwardly meek yet inwardly mysterious and powerful.

It's also telling that the only person other than Dietmar to appear as subject in the book is his mother, who inspired the work initially. This evocative portrait speaks to a deeper theme informing the work, only hinted at in the simple, plaintively two-dimensional storybook illustration-like arrangements of flower parts, such as *Field* and *Angel.* One of the earliest collages, *Flower on Blue*, is disarmingly elementary. Iris and lily petals combine to form a sort of stylized bird, forecasting the distinctly avian aspect of a number of the later images. It hardly matters whether this is an intentional reference to the aboriginal European (and apparently universal) "Mother Goddess" religion, one of whose primary symbols is referred to as the Bird Goddess. This macro-cosmic or biospheric drama echoes the microcosm of Dietmar's early life, our mother the Earth imperiled by a violently rationalist, reductivist and militaristic male principle.

Busse's art has antecedents in the vegetable portraits of Arcimboldo, especially recalled by *June 6, 2002*, as well as in the nineteenth century German folk art and illus-tration tradition featuring weirdly anthropomorphic plants. Their foundation in mysti-cism, pronounced especially in works like *Amazon Krishna*, make his tribal references clearest in *Papua New Guinea* for example, seem kindred rather than romanticized. Busse is pointing up the irrationality belying our technological era, as well as a sense of the fantastic permeating life in this brutal and purportedly secular age.

Interestingly, given Dietmar's personal history, it's difficult to think of other con-temporary images of a nude adult that seem as appropriate—fanciful and unthreat-ening—for youngsters. The most complex of the collages, the wonderful *Self Portrait as a Child* underscores these works' being rooted in childhood. Here then are totems

of a child's survival, and a man's blossoming, that quietly summon the imagination's innocence and fury, what Wallace Stevens called "the violence within that must counter the violence without."

Tom Breidenbach
December 2002

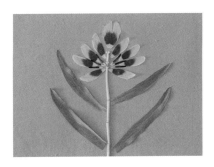

PLANT INDENTIFICATION

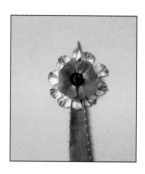

FLOWER, DECEMBER 4, 2002

Dianthus (carnation)
Anemone coronaria (anemone)
Aloe

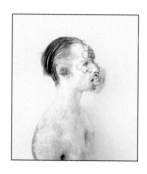

JUNE 6, 2002

Dianthus (carnation)
Scabiosa
Helianthus (sunflower)

FLOWER ON BLUE, DECEMBER 1999

Iris (Dutch iris)
Lilium (lily)

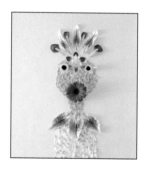

SELF PORTRAIT AS A CHILD, APRIL 1999

Iris (Dutch iris)
Dendrobium orchid
Gerbera
Chrysanthemum
Lilium (lily)

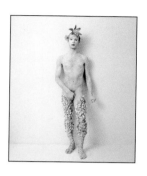

NOVEMBER 21, 2002

Hibiscus rosa-sinensis (hibiscus)
Lilium (lily)

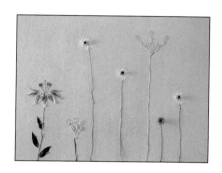

FIELD, APRIL 1999

Lilium (lily)
Gerbera
Iris (Dutch iris)

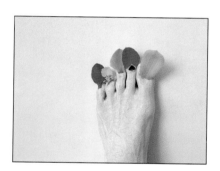

FOOT, NOVEMBER 2002

Cyclamen
Oncidium orchid
Tulipa (tulip)
Cymbidium orchid

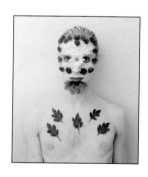

MARCH 5, 2002

Callistephus chinensis (China-aster)
Leucanthemum (Shasta daisy)
Anemone coronaria (anemone)
Chrysanthemum leaves

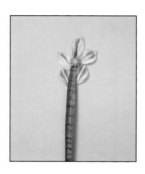

FLOWER, DECEMBER 5, 2002

Hippeastrum (amaryllis)
Gymnocalycium mihanovichii (cactus)
Sansevieria

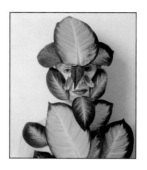

DECEMBER 6, 2002

Dieffenbachia

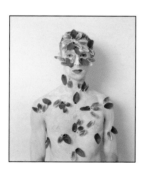

NOVEMBER 26, 2002

Tulipa (tulip)

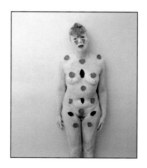

MY MOTHER, MARCH 2002

Rosa (rose petals and leaves)

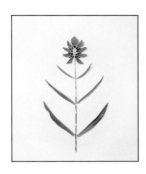

TULIP, DECEMBER 2002

Tulipa (tulip)

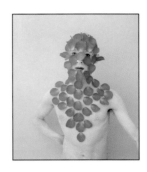

JANUARY 18, 2002

Rosa (rose petals)

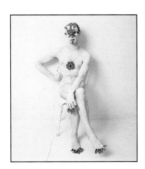

NOVEMBER 22, 2002

Anemone coronaria (anemone)
Tulipa (tulip)

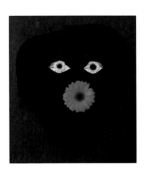

ANGEL, MAY 1999

Chrysanthemum (blue)
Gerbera

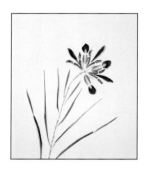

IRIS, DECEMBER 2002

Iris (Dutch iris)

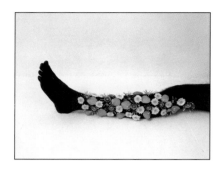

LEG, DECEMBER 2002

Rosa (rose)
Chrysanthemum (blue and white)

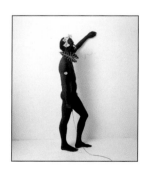

PAPUA NEW GUINEA, NOVEMBER 2002

Gladiolus
Chrysanthemum
Alocasia amazonica

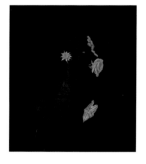

GAUGIN, JUNE 2002

Chrysanthemum
Helianthus (sunflower)
Rosa (rose)
Caladium

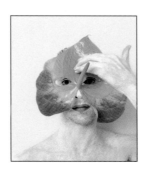

VENICE, DECEMBER 2002

Anthurium

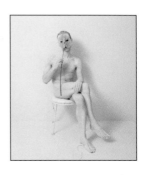

NOVEMBER 31, 2002

Anthurium

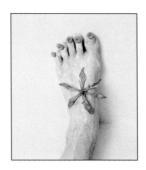

FOOT, DECEMBER 2002

Chrysanthemum
Gloriosa superba 'Rothschildiana'
(gloriosa-lily)

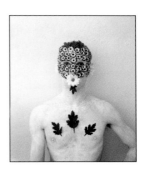

MARCH 6, 2002

Pericallis (cineraria)
Leucanthemum (Shasta daisy flowers
and leaves)

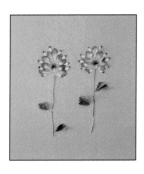

COUPLE, APRIL 1999

Pericallis (cineraria)
Freesia
Pelargonium (geranium petals
 and leaves)

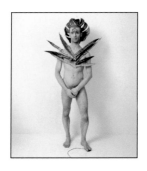

AMAZON KRISHNA, DECEMBER 2002

Monstera deliciosa (leaf)
Phalaenopsis orchid
Sansevieria (leaves)

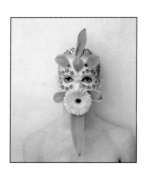

MARCH 2, 2002

Tulipa (tulip petals and leaves)
Chamelaucium (wax flower)
Oncidium orchid
Gerbera

FLOWER, DECEMBER 3, 2002

Chrysanthemum
Anemone coronaria (anemone)
Sansevieria